POCKET GUIDES

IMPRESSIONISM

Kathleen Adler

NATIONAL GALLERY PUBLICATIONS LONDON

DISTRIBUTED BY YALE UNIVERSITY PRESS

This publication is supported by
The Robert Gavron Charitable Trust

THE POCKET GUIDES SERIES

Front cover and title page:
Claude-Oscar Monet, *Bathers at La Grenouillère*, detail of 2.

First published in Great Britain in 1999 by
National Gallery Publications Limited
St Vincent House, 30 Orange Street, London WC2H 7HH

ISBN 1 85709 223 6

525284

British Library Cataloguing-in-Publication Data.
A catalogue record is available from the British Library.
Library of Congress Catalog Card Number: 99-70236

Edited by John Jervis
Designed by Gillian Greenwood
Printed and bound in Germany by Passavia Druckservice GmbH, Passau

CONTENTS

FOREWORD

The National Gallery contains one of the finest collections of European paintings in the world. Open every day free of charge, it is visited each year by millions of people.

We hang the pictures in the Collection by date, to allow those visitors an experience which is virtually unique: they can walk through the story of Western painting as it developed across the whole of Europe from the beginning of the Renaissance to the end of the nineteenth century – from Giotto to Cézanne – and their walk will be mostly among masterpieces.

But if that is a story only the National Gallery can tell, it is by no means the only story. The purpose of this new series of *Pocket Guides* is to explore some of the others – to re-hang the Collection, so to speak, and to allow the reader to take it home in a number of different shapes, and to follow different narratives and themes.

Christian saints, and the angels who bless so many of the earlier works in the Gallery, shed light not only on the meaning of individual pictures but also on the functions of religious art in European society. Colour, that fundamental ingredient of painting, is shown to have a history, both theoretical and physical – and Impressionism, perhaps the most famous and certainly the most popular episode in that history, is revealed to have been less a unified movement than a willingness to experiment with modern materials and novel subject matter.

These are the kind of subjects and questions the *Pocket Guides* address. Their publication, illustrated in full colour, has been made possible by a generous grant from The Robert Gavron Charitable Trust, for which we are most grateful. The pleasures of pictures are inexhaustible, and our hope is that these little books point their readers towards new ones, prompt them to come to the Gallery again and again and accompany them on further voyages of discovery.

Neil MacGregor
DIRECTOR

INTRODUCTION

WHAT IS IMPRESSIONISM?

Impressionism is so familiar today that we all assume we know what it is. We think of an Impressionist painting as a contemporary landscape or a scene of modern life, often one of sunlit leisure. Impressionist paintings appear to be spontaneous, made on the spot, almost casual about the choice of subject matter, and to have been done quickly. These are paintings in which a highly polished surface, with individual brushstrokes barely visible, gives way to an assertion of the marks on the canvas, to a conscious rejection of any attempt to disguise the process of how the picture was made, and to an emphasis on the individual 'handwriting' of the artist. Such paintings are free of references to the great biblical, mythological and historical narratives [1] which had flourished in European art for centuries, the representation of which continued to be the mainstay of the instruction students received at such art schools, or 'academies', as the Ecole des Beaux-Arts in Paris throughout the nineteenth century.

1. Paul Delaroche, *The Execution of Lady Jane Grey*, 1833. 246 x 297 cm.

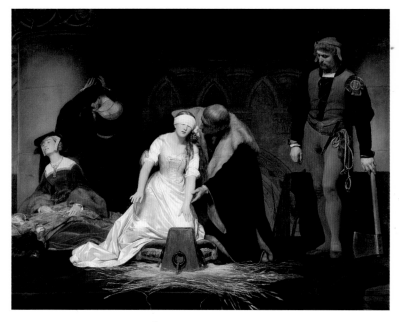

Another definition of Impressionism might be that it is work by a particular group of artists who freed themselves from the constraints of the official forum for exhibiting paintings in nineteenth-century France, the Paris Salon. The process of selection by jury at the Salon, and the dense hang of pictures on the walls of its venue, the Palais de l'Industrie off the Champs-Elysées, made it difficult for those showing small landscape paintings to have their work recognised. This led many who were out of sympathy with the artistic preferences of the jury to consider other approaches to exhibiting, so that they might be independent both of this system and of the growing network of art dealers in Paris. Discussions before the Franco-Prussian War of 1870–1 about constituting a separate exhibiting group came to nothing, but in 1874 the first of a series of independent shows was held. The artists involved were dubbed 'Impressionists' by a hostile critic, reacting to Monet's painting *Impression, Sunrise* (Paris, Musée Marmottan), a name which stuck despite their initial rejection of the term. In all, there were eight exhibitions of such 'independents' held in Paris between 1874 and 1886, which have come to be known as Impressionist exhibitions.

The number of artists who participated was far greater and the range of their work far more various than the definition of Impressionism I have just outlined might suggest: many of them were not landscapists, they did not all paint with the same broad brushstrokes and vivid palette, nor did they agree about a philosophy or a set of artistic aims. And to define Impressionism as consisting of works by artists who exhibited at these independent shows, and as restricted to this twelve-year period, is not really satisfactory, because it includes the work of artists barely known today, such as Raffaëlli and Zandomeneghi; more importantly, it does not allow for the different views of even those artists who showed at the first exhibition. Monet and Renoir, for example, both wearied of the independent shows and sought other avenues in which to display their work, while Pissarro and Degas, despite their very different approaches, were committed to the principle of independence from the Salon. This definition does not encompass the sheer range and variation of 'Impressionist' art.

THE BEGINNINGS OF IMPRESSIONISM

Claude Monet's *Bathers at La Grenouillère* [2] might seem to be the quintessential Impressionist picture, if open-air painting, scenes of leisure, and sunlight reflecting on water make Impressionism. Monet visited La Grenouillère, a bathing place on the Seine not far from Paris, with his friend Pierre-Auguste Renoir in the summer of 1869. He attempted to find a pictorial language that matched his perception of this lively scene of men and women strolling in the sun in their fashionable finery, boating and swimming in the undoubtedly murky river. The work was undertaken out of doors, and Monet vividly conveys the sense of looking down at the bobbing rowing boats, then at the narrow walkway which bisects the canvas, and then beyond, to the distant view of the river. Broad brushstrokes delineate the boats; the

2. Claude-Oscar
Monet,
*Bathers at La
Grenouillère*,
1869. 73 x 92 cm.

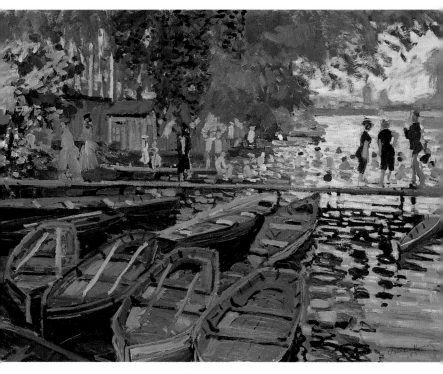

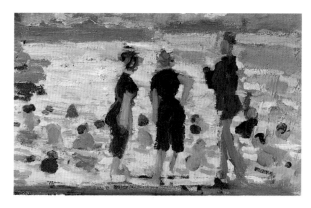

3. Detail of 2. trees to the right of the scene are mere blurs of colour, through which Monet has scored lines with the handle of his paintbrush, impatient to mark out the main areas. The glitter of sunlight on the river, the intensity of Monet's observations, his enjoyment of the bustle of this none too respectable resort are brilliantly conveyed. The three figures to the right on the walkway [3] remind us that Monet had been a caricaturist during his teenage years: he instantly captures their mood and class in his shorthand – note the extravagant pose of the central figure in her bathing suit, hand on jutting hip. This is clearly a working-class woman, intent on enjoying herself at

4. Detail of 2. this popular spot by the river.

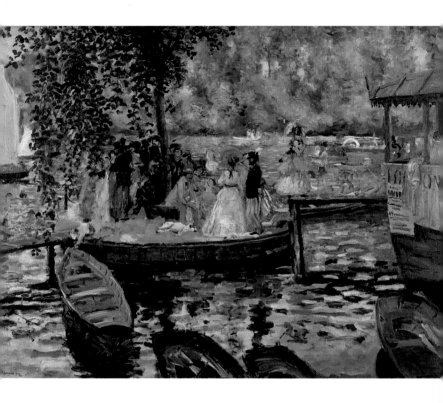

The summer of 1869 marked an important staging post towards that defining moment when 'Impressionism' officially came into being five years later. The National Gallery's painting is one of several views Monet painted of La Grenouillère, very similar in intent and composition to those painted by Renoir [5]. We can readily imagine the two young men working side-by-side, trying to capture their 'impression' of the ever-changing scene in front of them. The experience of working together, avidly discussing how to capture the effect of the landscape, was one of the crucial elements in developing a new approach to painting, freed from the restrictions of theory as taught in the Academy, and based far more on personal experience. Monet's painting is so captivating, so accomplished in its own terms, that it is a shock to realise that the artist himself himself regarded it as one of a series of poor sketches ('*mauvaises pochades*'), created as a prelude to a larger, more finished painting which he hoped to submit to the Paris Salon.

5. Pierre-Auguste Renoir,
La Grenouillère,
1869. 66.5 x 81 cm.
Stockholm,
Nationalmuseum.

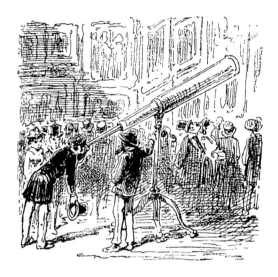

6. Pif, *Croquis*. 'At the Salon. A painter whose work is badly placed installs a telescope so that art lovers can see his picture for two sous ... which he gives them.' *Le Charivari*, 23 May 1880.

THE PARIS SALON

The Salon so dominated artists' thinking at this time that it is important to understand what it was and what it represented. Once biennial, by the late 1860s it was an annual, and ever more enormous exhibition of contemporary painting and sculpture, held in a series of huge halls in the now no longer extant Palais de l'Industrie. Visitors were confronted by great expanses of wall hung floor to ceiling with a miscellany of paintings, arranged alphabetically according to artist name, and displayed so close together that the frames of works sometimes overlapped. To walk around the Salon was an endurance test, to notice a small individual work a feat of observation and determination [6]. The works in the Salon were selected by a jury, and an elaborate tiered system of honours and awards applied. Those who were awarded prizes became '*hors concours*',

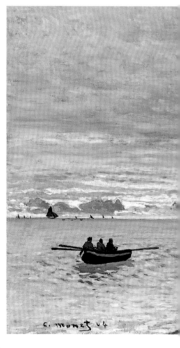

10

and in future years no longer had to submit them-selves to the vagaries of jury selection.

For the twenty-nine-year-old Monet and his colleague Renoir, a year younger, success at the Salon still seemed of paramount importance, something elusive and unpredictable. Large pictures with strong compositions stood the best chance of being noticed, and both artists applied themselves assiduously during the 1860s to producing works of sufficient stature and size to make their mark on the Salon walls. The National Gallery's earliest work by Monet, *La Pointe de la Hève, Sainte-Adresse* [7], is a study for his first successful submission to the Salon, accepted in 1865. Painted on the Normandy coast, close to his childhood home in Le Havre, it demonstrates qualities that were to dominate his painting throughout the six decades of his career: his fascination with the impact of changing light on the appearance of a landscape; his preoccupation with water; and his determination to find a match between what he perceived – his 'sensations', to use a word associated with Paul Cézanne, but equally relevant to Monet and his col-leagues – and the manner in which these perceptions were to be represented. Even in this early work, the

7. Claude-Oscar Monet, *La Pointe de la Hève, Sainte-Adresse*, 1864. 41 x 73 cm.

pearly tonality, the assurance with which the simple composition is handled, and the concern with capturing exactly the effect of the glistening wet shingle and the line of the wavelets, all presage the Monet to come, the Monet of *The Water-Lily Pond* of 1899 [64], and even the Monet of the vast 'decorations' of the 1910s and 1920s based on the same ponds at his home in Giverny.

The immediate inspiration for Monet and Renoir in the 1860s came from several sources. Important among them was the work of Gustave Courbet, the Realist painter, who in paintings like *Young Women on the Bank of the Seine* [8] had shown his desire to remake the traditional nude, derived from the idealised forms of classical Greek and Roman sculpture, into a modern subject. Courbet's Realism also embraced the idea that contemporary life was an appropriate subject for painting. The artists known as the Barbizon school (after their taste for painting in the forest around the village of Barbizon outside Paris) were also

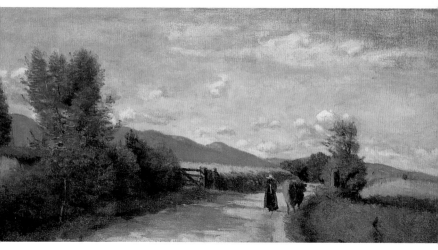

crucially important, in particular Camille Corot and Charles Daubigny, who worked out of doors, capturing changing effects of light. Their insistence on painting in front of the subject – *sur le motif* – at least for initial sketches, and their attempts to render subtle changes in tonality, reflecting changes in light and atmosphere, greatly affected the younger generation of Monet, Renoir, and Sisley. Many of their paintings, for instance Corot's *Dardagny, Morning* [10], are very small, and suggest a specific season and time of day. Although these artists worked tonally, that is, within the range between white and black rather than using

9. Charles-François Daubigny, *The Garden Wall*, 1860–78. 18.7 x 35.9 cm.

10. Jean-Baptiste-Camille Corot, *Dardagny, Morning*, 1853. 26 x 47 cm.

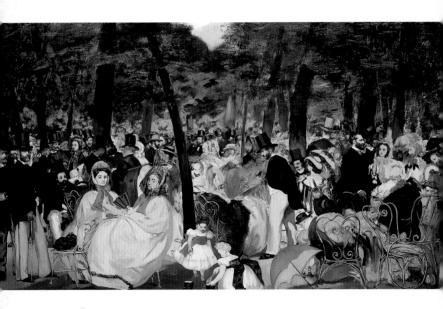

vivid colours as the Impressionists were to do, their embrace of nature not only as a subject but as an authority – an alternative authority to the works of the Old Masters – was profoundly influential.

The other great inspiration was Edouard Manet. He was only a few years older than most of the Impressionists, and younger than one, Camille Pissarro. His paintings of modern life rocked the Paris art world, and his impact on painters intent on conveying contemporary Paris was inescapable. *Music in the Tuileries Gardens* of 1862 [11] demonstrates his disdain for conventional composition – rather than a clearly defined focal point, the painting has at its centre a blurred mass of chairs, trees and crowd. The figures represent some of the key players in the Parisian arts scene of the early 1860s: Manet himself, partly cropped on the extreme left [12]; fellow artists such as Henri Fantin-Latour and the animal painter Albert de Balleroy; the composer Jacques Offenbach; the critic Jules Champfleury; the poet and critic Charles Baudelaire; and the novelist and critic Théophile Gautier. Baudelaire was a passionate advocate of the idea that every age has its own form of beauty, and that every artist must strive to find a way to represent 'the heroism of modern life' – an important concept both for Manet and for the Impressionists.

14

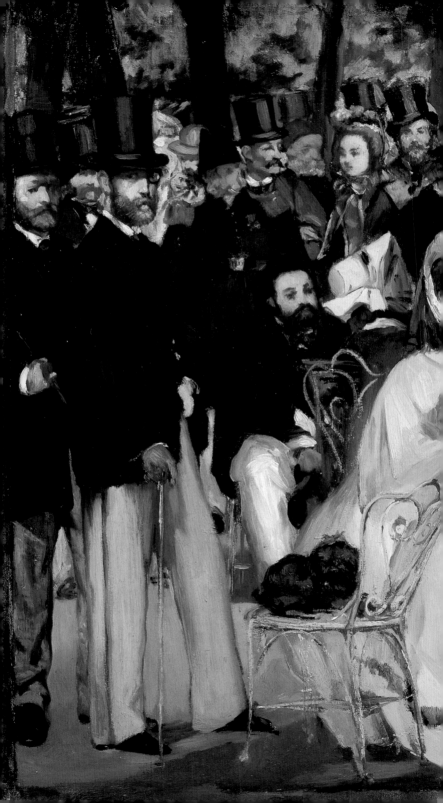

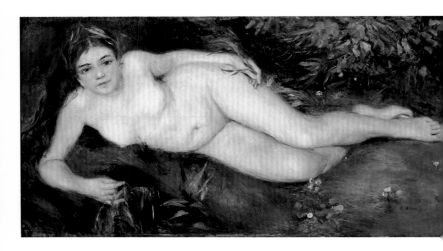

Renoir showed his indebtedness to this range of influences in *A Nymph by a Stream* [13] of around 1869. The nude figure reclining on a river bank, almost a part of the natural surroundings, is a traditional subject linking Woman and Nature, but the unidealised body and pert Parisian face (recognisable as Lise Tréhot, Renoir's favourite model at the time) bring the image up to date. Courbet's depictions of women, such as *Young Women on the Bank of the Seine*, had challenged conventional expectations concerning the representation of women, and Manet was forever branded by the notoriety of his images of the contemporary nude, for instance in *Le Déjeuner sur l'herbe* [15]. Renoir's figure proved less controversial than Courbet's or Manet's, but its immediate ancestry is clear.

MONET
AND
PISSARRO
IN
LONDON

During the 1860s the artists who would become known as the Impressionists were experimenting, trying out a variety of approaches and looking to a range of influences. They had already toyed with the idea of exhibiting as a group, independently of the Salon, but the Franco-Prussian War of 1870–1, and the subsequent Commune, marked an important

13. Pierre-Auguste Renoir, *A Nymph by a Stream*, 1869–70. 66.7 x 122.9 cm.

14. Detail of 13.

15. Edouard Manet, *Le Déjeuner sur l'herbe*, 1863. 89.5 x 116.5 cm. London, The Courtauld Gallery.

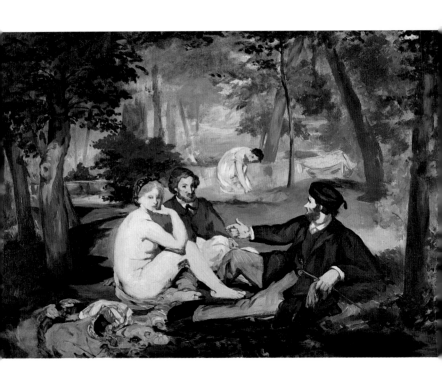

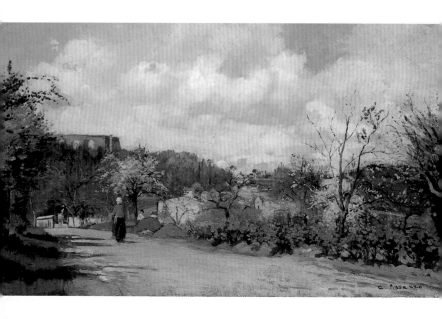

16. Camille Pissarro, *View from Louveciennes*, 1869–70. 52.7 x 81.9 cm.

17. Camille Pissarro, *Fox Hill, Upper Norwood*, 1870. 35.3 x 45.7 cm.

watershed. Both Monet and Camille Pissarro, ten years older and a pupil of Corot, came to London. Pissarro settled in south London, in Norwood, later describing it as 'at that time a charming suburb'. He had been living in Louveciennes, to the north-west of Paris, near the Marly aqueduct, which he represented in his *View from Louveciennes* [16] made shortly before his departure for England. The composition, with the road winding into the background, and the various figures establishing a human presence and scale, is strongly reminiscent of Corot. Pissarro's work in London continued along these lines.

Fox Hill, Upper Norwood [17], painted during his first winter in England, records the characteristic architecture and colour of south London houses, and vividly conveys the sense of the rutted road and the dirty snow. The perspective created by the road and the small figures used to indicate scale again suggest Corot's influence. Pissarro wrote later that while in London he 'studied the effect of fog, snow and spring-time', and in *The Avenue, Sydenham* [18], we see one such springtime scene. The broad suburban road leads to a church in the background, St Bartholomew, Westwood Hill, and the road is clearly identifiable with what is now Lawrie Park Avenue in Sydenham. It is a tranquil scene, with clusters of figures on the

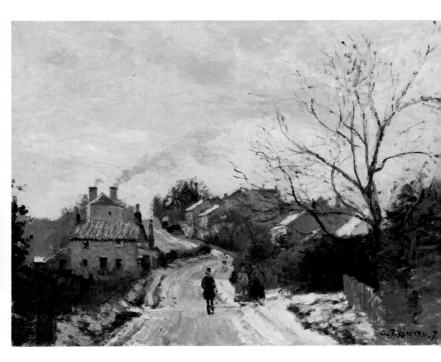

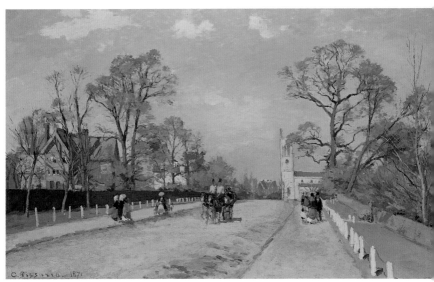

pavements and brilliantly green grassy verges by the road, and is notable for its greater brightness of hue in comparison to the earlier work, and its diminishing reliance on tonal values.

18. Camille Pissarro, *The Avenue, Sydenham*, 1871. 48 x 73 cm.

19. Eugène
Boudin,
*Beach Scene,
Trouville,*
about 1860–70.
21.6 x 45.8 cm.

20. Claude-Oscar
Monet,
*The Beach at
Trouville,* 1870.
37.5 x 45.7 cm.

Monet came to London with his new bride, Camille
Doncieux, and their three-year-old son Jean. Just
prior to leaving France, he had painted Camille and a
companion, probably the painter Eugène Boudin's
wife, sitting on the beach at Trouville in Normandy.
Boudin was renowned for his paintings of this stretch
of sand [19], and Monet's small sketch [20] encapsu-
lates the whole idea of painting on the spot: parts of
the primed canvas are left bare, as in the area around
the artist's initials and the date – 'Cl. M. 70'; the edge
of the sleeve of Camille's dress is captured in a single
calligraphic line, the sunlit patch on her white skirt

by a few short strokes of pure white, applied with a loaded brush. The presence of grains of sand embedded in the paint, visible even to the naked eye, is a clear indication that the painting was done entirely in the open air, in one brief, windy session. Clouds scud across the sky, the beach is almost deserted, and the speed of execution is felt in every aspect of the work – the mask-like shorthand by which Monet describes Madame Boudin's face, for example [21].

21. Detail of 20.

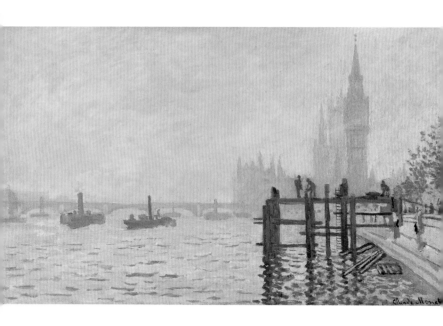

22. Claude-Oscar Monet, *The Thames below Westminster*, about 1871. 47 x 72.5 cm.

In London, Monet was drawn to some of the more striking attractions of the city, rather than the quiet ordinariness of the suburbs which Pissarro enjoyed. *The Thames below Westminster* [22] may appear to show the heart of traditional London, but in fact all the elements in Monet's painting, the Houses of Parliament, Westminster Bridge, and the Victoria Embankment, were new, or even under construction (like the structure in the foreground, which may be part of the Victoria Embankment or perhaps the Admiralty steps). What Monet was painting would, in 1871, have seemed strikingly modern. The misty haze, through which the architectural forms emerge in silhouette, and the stark geometry of the foreground structure, suggest Monet's interest in Japanese woodblock prints and in the work of his near-contemporary, the American-born James Abbott McNeill Whistler, for whom the Thames was a compelling subject [23]. These influences are still evident in a more traditional composition, *The Petit Bras of the Seine at Argenteuil* [24], one of several views of this backwater just downstream of Argenteuil painted by Monet on returning to France in 1871.

22

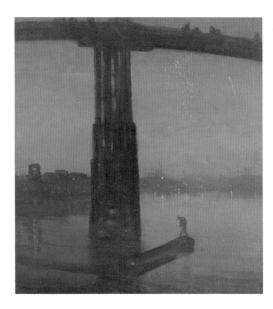

23. James Abbott McNeill Whistler, *Nocturne in Blue and Gold: Old Battersea Bridge*, c.1872–5. 67.9 x 50.8 cm. London, Tate Gallery.

24. Claude-Oscar Monet, *The Petit Bras of the Seine at Argenteuil*, 1872. 52.6 x 71.8 cm.

THE IDEA OF
AN IMPRESSIONIST
EXHIBITION

On regrouping in Paris after the Franco-Prussian war, it became increasingly evident to the nascent Impressionists that they might be better served by establishing an exhibition forum of their own, rather than relying on the vagaries of the Salon. In 1874 they, and other artists who had grown frustrated with the official avenues for the exhibition of paintings, formed a co-operative society. This association was intended to free them from the tyranny of jury selection at the Salon, and from the growing importance of the network of art dealers. All the participants would be given an equal opportunity to show a limited number of works, well displayed and thoughtfully hung. This *Société anonyme des artistes peintres, sculpteurs, graveurs, etc.* (the name a deliberate attempt to avoid labelling the group) opened its first show at the premises of the famous photographer Nadar on 35 boulevard des Capucines in Paris on 15 April 1874.

Impressionism was named, like many subsequent art movements, by hostile critics. Many were perplexed by the apparent absence of drawing and of conventional skills in creating the illusion of three-dimensional shapes and spaces. One critic, Louis Leroy, famously said 'They're nothing but a bunch of Impressionists'. The name also makes reference to a tradition of landscape paintings which render specific moments and effects, or impressions. The title 'Impressionist' stuck firmly. Many critics were sympathetic to their aims, but the number of visitors and of sales at the show was small, and from the outset alternatives, including other loose groupings of artists and strategic sales at auction, were considered by all the participants. There was no binding charter or single shared set of aims and ideals, and this meant that future exhibitions were dogged by disputes about who would or would not participate, and about the value of the group exhibitions for the individuals involved. In spite of this, eight group shows under this umbrella term were finally held, with very varying participation, the last in 1886.

25. Detail of 27.

24

Renoir's work in the 1870s seems to encapsulate all the elements we understand as constituting Impressionism. Modern urban life, and in particular the world of entertainment, are the focus of paintings like *La Loge* [26]. Painted about 1876 or 1877, *At the Theatre (La Première Sortie)* [27] shows a young girl and her older companion in a box at a theatre. Other members of the audience are visible, but the stage is nowhere to be seen. Scenes of the theatre, the opera, and the other entertainments of night-time Paris were popular subjects with the Impressionists as with Manet, and here Renoir captures something of the

26. Pierre-
Auguste Renoir,
La Loge, 1874.
80 x 63.5 cm.
London,
The Courtauld
Gallery.

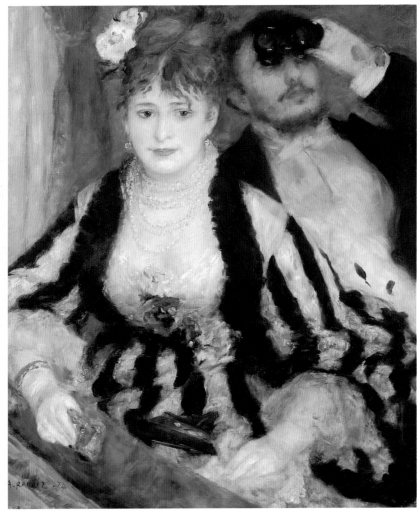

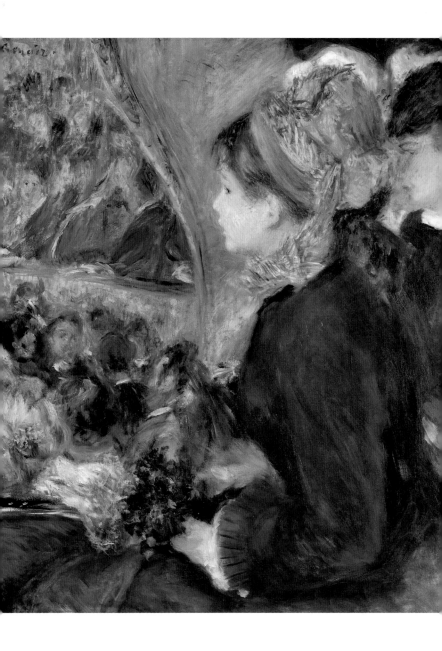

excitement of a young girl's experience of visiting a crowded theatre. It is for this reason that the painting was given its alternative title, *The First Visit (La Première Sortie)*, not by Renoir himself but in the 1920s, since the painting seems to invite us to construct a story round it.

27. Pierre-Auguste Renoir, *At the Theatre (La Première Sortie)*, 1876–7. 65 x 49.5 cm.

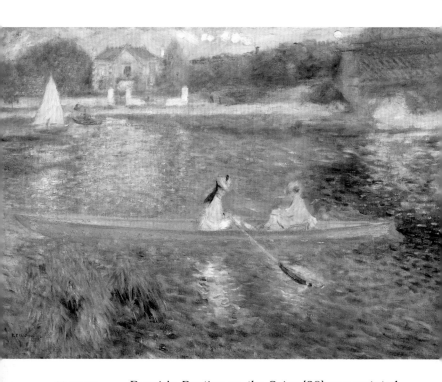

28. Pierre-Auguste Renoir, *Boating on the Seine*, about 1879–80. 71 x 92 cm.

Renoir's *Boating on the Seine* [28] was painted some five years after the first group show. It shows an idyllic sunny day on the Seine, perhaps at Asnières, but more likely at Chatou, where Renoir worked frequently at the end of the 1870s. Sun glints off the surface of the water, which is painted in recognisably separate dabs of paint. The two fashionably dressed young women epitomise the idea of leisure and pleasure which seems so intrinsic to Impressionism's lasting appeal. The vivid blues and oranges demonstrate how far painters had moved from the subtle tonal gradations of earlier landscapists like Corot. These colours are at opposite ends of the colour spectrum, and are known as complementary colours because they enhance each other when placed together. Here, the orange looks more orange, the blue bluer, because of their proximity. The railway bridge on the right establishes this site as one of a number of spots on the Seine linked to Paris by the railway system, and so a short journey from the Gare St-Lazare in the centre of the city. A train can just be spotted, its plume of smoke merging with the clouds, while the white disc of a railway signal just above the

pier of the bridge can also be seen. Renoir, who was deeply nostalgic for what he perceived as the happier times of the eighteenth century, saw no difficulty in incorporating such signs of modernity in his paintings, and this easy acceptance of industrialisation and change was shared by almost all the Impressionists.

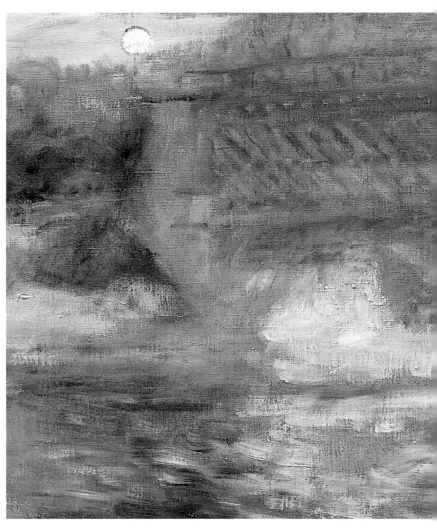

The development of the railway system in France linked towns like Argenteuil, Asnières and Chatou to Paris, and made areas further afield, such as Brittany, more accessible. For Monet, the trains and stations were objects of particular fascination,

MONET
AND
THE
RAILWAYS

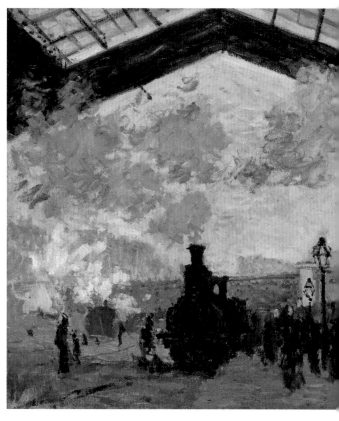

30. Claude-Oscar Monet, *The Gare St-Lazare*, 1877. 54.3 x 73.6 cm.

and in 1877 he embarked on a number of paintings, eleven in all, of the sheds and tracks of the Gare St-Lazare and of the Pont de l'Europe leading to the station. *The Gare St-Lazare* [30] is one of four painted within the station itself. Monet set up his easel at the terminus of one of the main lines looking along the platforms and tracks to the Pont de l'Europe in the middle distance. He shows the bustle of the crowded station, passengers moving onto the trains, the three locomotives making smoke, the whole scene framed by the triangular roof of the shed. Smoke breaks up the geometry and clarity of both architecture and machines, so that the effect is mysterious and exciting, conveying the 'romance of steam' and the particular thrill of setting out on a journey. Monet may well have known Turner's *Rain, Steam and Speed* [31], which he could have seen in London, but the effect here is not based on imitation but on a shared delight in this form of transport.

30

31. Joseph Mallord William Turner,
*Rain, Steam, and Speed –
The Great Western Railway*, before 1844.
90.8 x 121.9 cm.

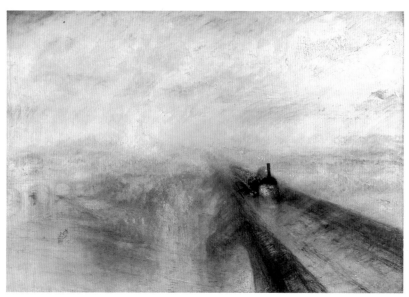

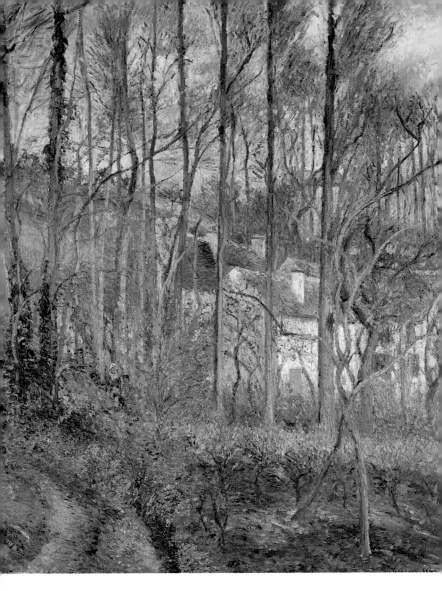

Given the number of shared concerns, both artistic and cultural, one might assume that Impressionism was a fairly unified movement, but this was far from the case. The various painters involved were united largely in their belief in an exhibition forum independent of the Salon and the dealers, but had different ideas about how to approach the challenge of painting modern-life subjects. While Monet and Renoir favoured the possibilities of conveying the brilliance and sparkle offered by river subjects,

Pissarro was working steadily on the landscapes of the Pontoise region where he had moved in 1886. He embarked on this ambitious painting, *The Côte des Boeufs at L'Hermitage* [32], in the same year as Monet painted *The Gare St-Lazare*. L'Hermitage is a hamlet near the market town of Pontoise, set among rolling hills. The dense structure of the trees creates a grid through which the block-like shapes of the white houses with their red and grey roofs are seen, and the brushstrokes Pissarro used are very different from the freely applied, quick marks Monet made in *The Gare St-Lazare*. Pissarro worked and reworked the surface, so that details such as the figures emerging from the trees on the left are at first almost invisible. The surface of Pissarro's painting has often been described as 'woven', so densely and laboriously is the paint applied.

If Impressionism involves a quick response to an ever-changing scene, this cannot be an Impressionist painting. But Pissarro was the most devoted protagonist of the Impressionist exhibitions, the only artist to exhibit in all eight shows. The contrast between this painting, Monet's station and Renoir's women rowing shows something of the range of 'Impressionism'. What united the artists was that none at this stage of their career was interested in utilising historical or mythological references, or in providing a substantial 'story' in their paintings, but all were drawn to aspects of modern life, whether encountered in the city or the country.

32. Camille Pissarro, *The Côte des Bœufs at L'Hermitage*, 1877. 114.9 x 87.6 cm.

33. Detail of 32 under raking light.

Edgar Degas represents another facet of the diversity of the Impressionist movement. Like Pissarro, he was a fierce opponent of the Salon system and a vigorous supporter of the Impressionist exhibitions. Although Degas did occasionally paint landscapes, it was the human figure that fascinated him, whether at rest in an interior, or animated in dance. His relationship to the art of previous centuries, and to the category of history painting held in such high esteem in official circles, yet rejected by the other Impressionists, was a complex one, as indicated by *Young Spartans Exercising* [34]. Begun in 1860, the painting was reworked (as was often the case with Degas) around 1880. There are references in abundance in this work to the art and literature of the past, and a definite, although confusing, narrative. The picture's size and complexity suggests that Degas wished it to be seen as a history painting. Such works were generally figure paintings on a grand scale, with subjects derived not only from history but from classical mythology and the Bible. Degas's desire to exhibit the reworked version of an early history painting in one of the group shows is puzzling. But he always sought opportunities for experimentation (for instance in his frequent combination of a variety

34. Hilaire-
Germain-Edgar
Degas,
*Young Spartans
Exercising*,
about 1860.
109.2 x 154.3 cm.

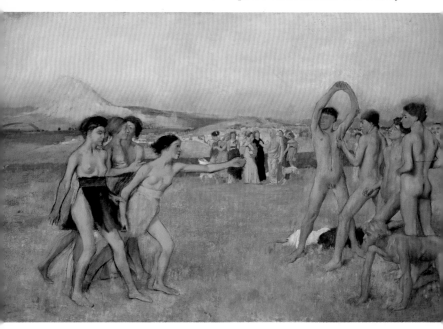

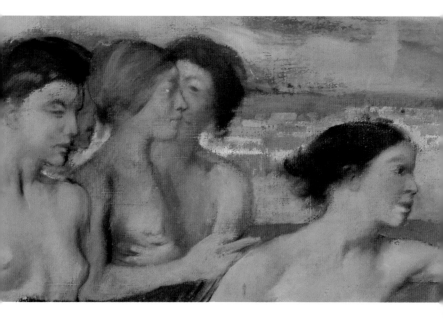

of techniques in his work) and saw these exhibitions as providing another such opportunity.

The painting shows the city of Sparta in ancient Greece, with two groups of adolescents, one female, one male, challenging each other to wrestle. Mention is made in Plutarch of Spartan girls and boys wrestling, as well as in other literary sources which Degas, well-read in the classics, is likely to have known. His nude or semi-nude figures are scarcely classical in their proportions or facial types, and one of the consequences of Degas's reworking of the painting twenty years after beginning it was to give the figures the appearance of Montmartre street urchins [35]. Degas, like many others at this period, was intrigued by the 'science' of physiognomy, whereby details of the face, for instance the proportion and slope of the forehead or jaw, were seen to indicate personality traits, particularly evidence of a criminal predisposition. Degas's figures, and the painting itself, bridge centuries and cultures, ostensibly showing a scene in Sparta but remaining very much of the nineteenth century. Degas suggests that the uncertainty and challenge of adolescent sexuality endures across this divide. The painting also highlights the fact that no artist can ever completely ignore the past and its traditions: Degas certainly had no wish to do so.

Degas's *Beach Scene* [36, 38] is probably contemporary with Monet's *The Gare St-Lazare* and Pissarro's *The Côte des Boeufs at L'Hermitage*. It was exhibited at the third Impressionist exhibition in 1877. All the other paintings discussed so far are on a canvas support, usually of a standard size purchased from a colour merchant. The availability of such prepared canvases, primed and ready for immediate use, is one of the factors, along with the availability of commercially prepared oil pigments in metal tubes, which makes the realities of painting at this date so different from those of earlier periods, when canvases had to be prepared and pigments ground in the studio. The sheer ease with which a painter could obtain a range of paints and canvases and tackle open-air subjects in the latter part of the nineteenth century is striking. But this simplicity was not for Degas: here he used three separate sheets of paper as the support for the picture. The paper was then mounted on canvas. The figures, like those of Monet's *The Beach at Trouville*, are ostensibly painted on a beach, but there is very little sign of the artist attempting to render the immediate impression before him. 'No art is less natural than mine', said Degas, and the artifice with which he crafted his paintings is evident here. Degas stressed that the painting was made in the studio, not *sur le motif*, and this is apparent in every aspect of the work. The figures are cut-outs positioned on the beach, the girl's bathing attire apparently pegged out on the ground. On the horizon, puffs of smoke from two ships

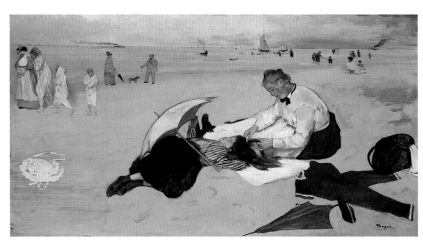

36

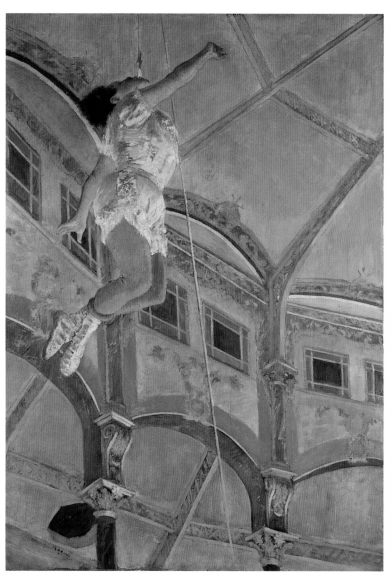

go in opposite directions in an unnaturalistic way.

Two years later, in 1879, at the fourth Impressionist exhibition, Degas showed his fascination with the life of modern Paris in *Miss La La at the Cirque Fernando* [37]. The circus, like the cafés, café-concerts, cabarets, ballet and opera, was an essential part of Parisian night-life. Most were permanent structures, not the itinerant events we now know – the Cirque Fernando was on the boulevard Rochechouart.

37. Hilaire-Germain-Edgar Degas,
Miss La La at the Cirque Fernando, 1879.
116.8 x 77.5 cm.

NEXT PAGE
38. Detail of 36.

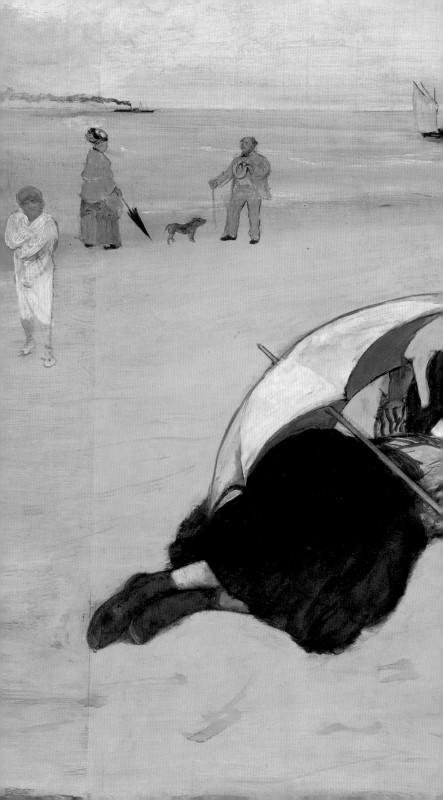

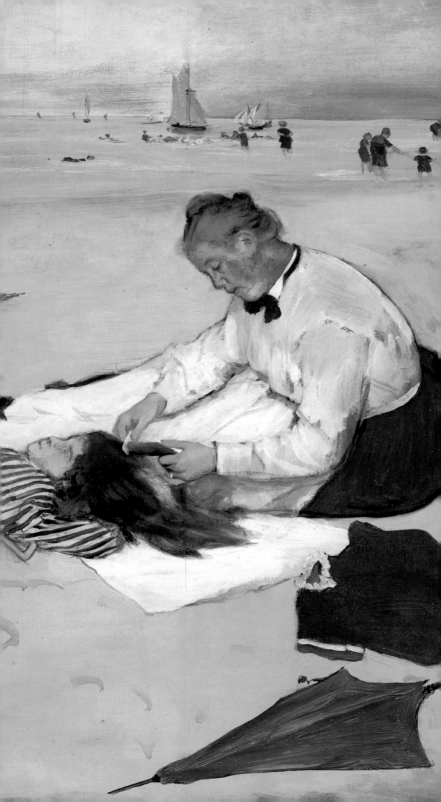

Miss La La was a star, renowned for the daring trapeze act which involved her gripping the rope with her teeth, and of mixed race, as a detail of her head makes clear. Degas's fascination with physiognomy and its latent racism is marked here: it is Miss La La's otherness, the incredible, animal-like strength of her teeth and jaws [39], not just the fact that she performs in a circus troupe, that marks her. The startling contrasts of orange and green heighten the sense of artifice and wildness.

Degas also enjoyed caricature, as is evident in a portrait of his friend, the Italian cartoonist Carlo Pellegrini [40], painted around 1876. Pellegrini worked for *Vanity Fair* in England under the pseudonym 'Ape'. Degas himself apes Pellegrini's style in this fore-shortened view, looking down on the dandified figure standing in the wings of a theatre, cigarette in one hand, hat in the other, immaculate in his patent leather pumps. This work is a combination of water-colour, pastel and oil on paper, typical of Degas's relentless experimentation with techniques and media.

Degas, with his concern for depicting figures and contemporary society, and his relationship with traditional art, was in many ways more akin to Manet than to the Impressionist landscapists. But while Manet consistently declined to exhibit with the Impressionists, firmly believing that the Salon was the 'real field of battle', Degas was committed to the independent group.

40. Hilaire-Germain-Edgar Degas, *Carlo Pellegrini*, about 1876. 63.2 x 34 cm.

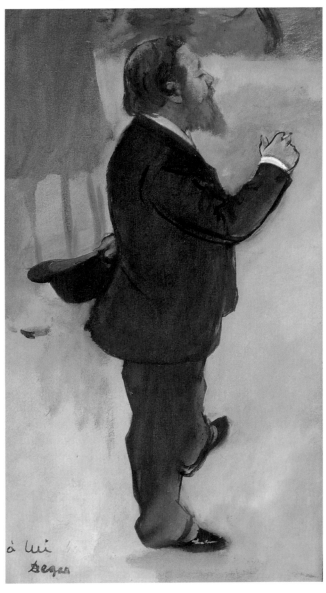

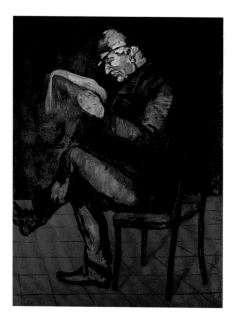

Cézanne's place in Impressionism has always been ambiguous. As one of the key figures in what the English critic Roger Fry named 'Post-Impressionism', he might be perceived as having somehow transcended the Impressionists. 'Post-Impressionist' implies building on the structure of the earlier movement and moving beyond it, but it is also a misleading term, since it was conceived after the death of the major artists so named – Cézanne, in other words, had no idea of defining himself as a Post-Impressionist. But he did make decisions about his relationship to the Impressionist exhibitions. Paul Cézanne was a year older than Monet, and two years older than Renoir. He came to Paris from his native Aix-en-Provence to study art, and was the son of a wealthy banker who, despite his disapproval of his son's career choice, allowed the large, ungainly early portrait, *The Painter's Father, Louis-Auguste Cézanne* [41], to be displayed in the family home.

Cézanne's friendship with Pissarro was crucial in introducing him to the latter's views, not only about painting but also about the options available for exhibiting his art. Works such as *La Maison du Pendu* [42], painted in 1873, and *Landscape with Poplars* [43], painted years later, show how he had taken Pissarro's lessons to heart and made them the basis

41. Paul Cézanne, *The Painter's Father, Louis-Auguste Cézanne*, about 1862. 167.6 x 114.3 cm.

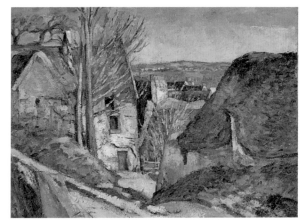

42. Paul Cézanne,
La Maison du Pendu, à Auvers-sur-Oise, 1873.
55 x 66 cm.
Paris, Musée d'Orsay.

43. Paul Cézanne,
Landscape with Poplars,
about 1883–8.
71 x 58 cm.

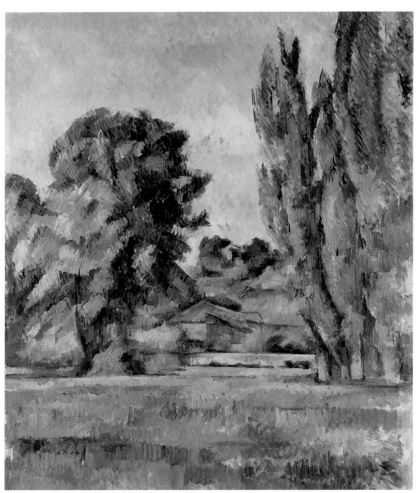

43

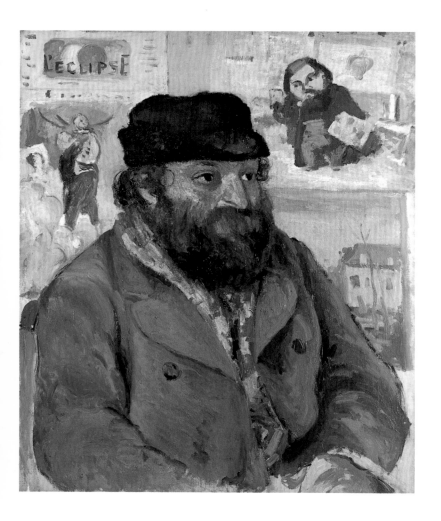

44. Camille Pissarro, *Portrait of Cézanne*, 1874. 73 x 59.7 cm.

of his own practice as a painter. Pissarro's portrait of Cézanne [44] was painted in the early 1870s, when the two men were working closely together in Pontoise. Cézanne is shown in Pissarro's studio, with one of Pissarro's own landscapes on the wall at the lower right, indicating that Pissarro did not underestimate his own role in showing his friend how to work more slowly, to observe more carefully, and to lighten and brighten his palette in comparison to his earlier work. The caricature of Courbet at the upper right in turn implies that the Realist Courbet is raising his beer stein to Cézanne, his successor. It is a generous tribute from Pissarro to his younger colleague. Cézanne's *Self Portrait* [45], painted a few years later,

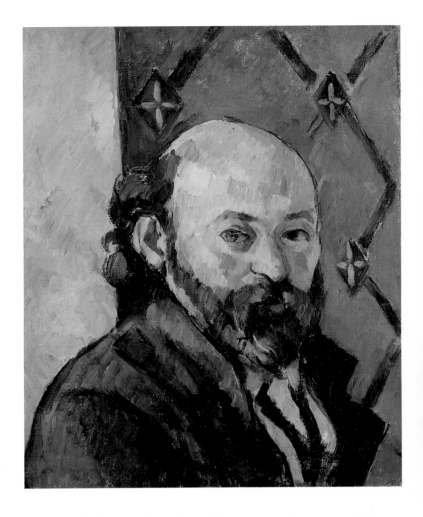

suggests that he saw himself as rather more austere and remote than Pissarro had chosen to portray him.

Cézanne exhibited at the first group show in 1874 and again at the third show, in 1877. Critics recognised that his work and that of Pissarro were distinct from the Impressionism of Monet and Renoir. 'Pissarro and Cézanne... together form a school apart, and even two schools within one', wrote a critic in 1877. Another used the word 'Intransigent' to describe Cézanne in the same year, and the term was adopted by many commentators. Originally used almost interchangeably with 'Impressionist', 'Intransigent' was redolent of a greater degree of dissent and provocation. The link between 'Intransigents' in art

45. Paul Cézanne, *Self Portrait*, about 1880. 33.6 x 26 cm.

and in left-wing politics was frequently made, and the group soon felt it necessary to distance themselves from this connection – the third exhibition was the first to accept the name 'Impressionist'. But the contest over the naming of the group reveals another of the splits within it, that of the political affiliations of its members. In 1882 Renoir grumbled to the dealer Paul Durand-Ruel: 'To exhibit with Pissarro, Gauguin and Guillaumin would be the same as exhibiting with a Socialist ... The public does not like what it feels is political and I do not want, at my age, to be a revolutionary.'

Cézanne, however, did not embrace 'revolutionary' politics. He regarded his place among this group of artists to be compromising, and did not show with them again after 1877. Like Manet, he instead sought success at the Salon, but it was not until 1882 that he finally had a work accepted. By this date, the Salon had changed its structure, and was controlled by the artists themselves rather than by the state-run Ecole des Beaux-Arts. Cézanne's acceptance failed to bring him recognition, and increasingly he cut himself off

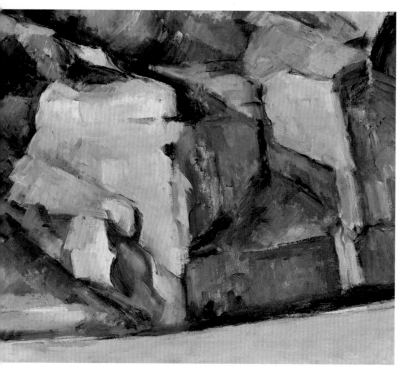

from the Impressionists and from the Paris art world, living an almost reclusive life in Provence. It was not until 1895 that the dealer Ambroise Vollard held an extensive exhibition of Cézanne's work in Paris, an exhibition that was a revelation to former friends and colleagues, among them Pissarro and Degas.

Cézanne's artistic credo, expressed to a journalist in 1870 and adhered to throughout his life, was one with numerous connections to Impressionism. He said: 'I paint as I see, as I feel – and I have very strong sensations.' *Hillside in Provence* [47] was painted in the mid-1880s. Its simple composition belies the care with which each element is placed, and the systematic ways in which colour is used to construct the almost geometric planes of the rocks [46]. Cézanne uses contrasts between complementary colours such as orange and blue to create his effects, but he also uses earth colours and black. His aim was to find a pictorial equivalent of his visual sensations, 'a harmony parallel to nature'. As we have seen, this was Monet's aim at least as early as the summer of 1869 at La Grenouillère – but with very different results.

47. Paul Cézanne, *Hillside in Provence*, probably about 1886–90. 63.5 x 79.4 cm.

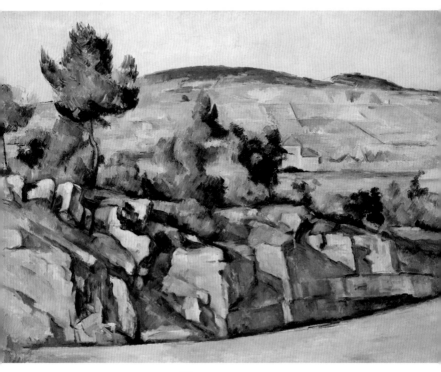

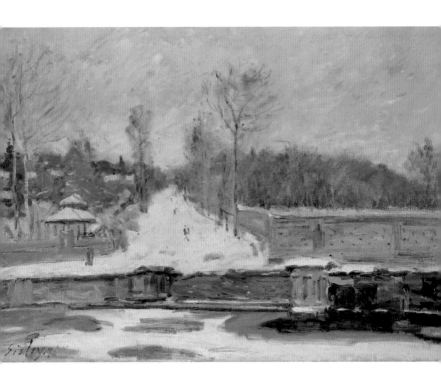

Two landscapists, in some ways the most strictly 'Impressionist' members of the group, have both, for different reasons, been somewhat neglected in the huge literature on the subject. They are Alfred Sisley and Berthe Morisot.

Alfred Sisley, born in Paris of British parentage, was one of Monet's and Renoir's companions in their student days in the early 1860s at the studio of the Swiss-born painter Charles Gleyre. He remained true to the practice of painting largely out of doors throughout his life. His paintings are generally quite low-key, which can in itself be seen to epitomise aspects of Impressionism – not for Sisley the wild or the dramatic, rather a precise and exacting observation of a specific motif, often a road or pathway in the environs of Paris.

The Watering Place at Marly-le-Roi [48] characterises this approach. The frozen watering place in the foreground is one of the few remaining vestiges of the grand past of Marly-le-Roi, marking the edge of the original park of the Château de Marly constructed for Louis XIV in the late seventeenth century and

48. Alfred Sisley,
*The Watering Place
at Marly-le-Roi*,
probably 1875.
49.5 x 65.4 cm.

destroyed in the 1790s. However, Sisley appears not be concerned with it as an emblem of past glories, only with its relation to the road beyond and the contrasts between the snowy ground, frozen water and leaden sky. The pinkish beige of the canvas ground shows through in many areas of the sky, only lightly covered by pigment, and we have a vivid sense of Sisley painting this scene as rapidly as possible, before his fingers froze to the brush. In this the painting is closely comparable to Monet's earlier *Beach at Trouville* [20], with its similarly vivid evocation of particular weather conditions.

Sisley was forced by financial constraints to move further away from Paris in the early 1880s, to the area around Moret-sur-Loing, where he remained for the rest of his life. *The Small Meadows in Spring* [49] shows a meadow path along the south bank of the Seine in this region. In contrast to the previous work, this painting suggests the brilliance of a warm spring day, the sunlight intense though many of the trees are not yet in leaf. The composition, with the small figures and the perspectival sweep of the path, reminds us of

49. Alfred Sisley, *The Small Meadows in Spring*, about 1880–1. 54.3 x 73 cm.

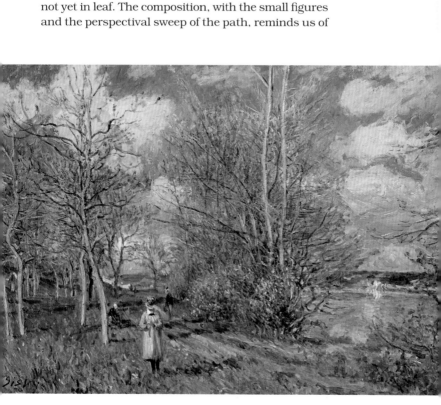

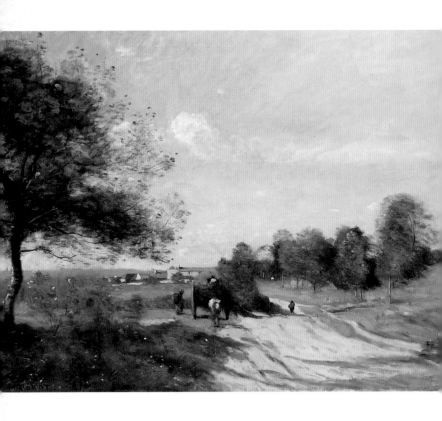

50. Jean-Baptiste-Camille Corot, *The Wagon ('Souvenir of Saintry')*, 1874. 47 x 56.8 cm.

51. Detail of 49.

the ongoing importance of Camille Corot's example for the Impressionist landscapists [50]. The central area, with its contrast between the verticals of the bare tree trunks and the rich texturing of the willow tree beyond, indicates that Sisley, like Pissarro, was becoming increasingly concerned with the texture and patterning of brushstrokes at this time, around 1880, moving away from the lightly brushed surfaces of many earlier paintings. The young girl in the foreground [51], in her simple blue smock, is characteristic of many figures in Impressionist painting. She is closely observed in some respects – the dress is of a colour note which relates to the sky and the water, and the long shadow suggests that it is late in the day – but her face is in shadow and her figure is not individualised in any way.

Morisot was originally the only female member of the Impressionist group, although she was later

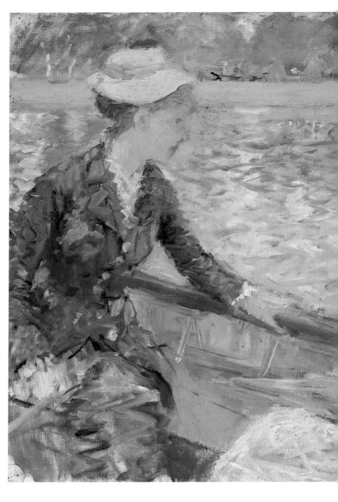

52. Berthe
Morisot,
Summer's Day,
about 1879.
45.7 x 75.2 cm.

joined by the American Mary Cassatt and by Marie
Bracquemond. In Morisot's *Summer's Day* [52], prob-
ably exhibited at the fifth group show in 1880, two
fashionably dressed young women sit in a rowing
boat on the Bois de Boulogne in Paris, close to
Morisot's home. Her sketchy touch is very evident in
the treatment of the water and the ducks, in the
quick zigzag brushstrokes which describe the skirt
of the woman on the left, and in the way the light-

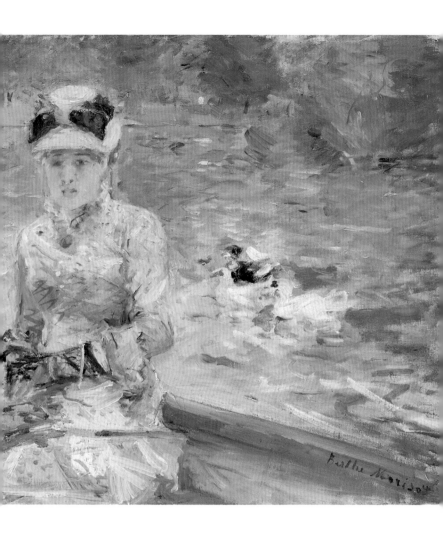

cream ground of the canvas shows through in many areas of the painting. Morisot was seen by many critics as the 'quintessential Impressionist' because her commitment to this freedom in the description of scenes of modern life never wavered, even at a point when some of her colleagues were reconsidering their approach. Some critics found the sketchiness of her work exasperating, asking: 'Why, with her talent, does she not take the trouble to finish?'

IMPRESSIONISM
IN CRISIS

By about 1880, many of the original participants in the 1874 Impressionist exhibition were rethinking their position. The group shows were proving increasingly troublesome to organise – changing allegiances among the artists were becoming marked, and the fact that Impressionism had never been a consistent 'style', or even a consistent philosophy about painting, made it difficult to preserve any sense of unity. The group exhibitions were proving relatively unsuccessful in terms of sales, and changing conditions at the Salon and the rapidly growing importance of art dealers like Paul Durand-Ruel and Georges Petit meant that other options began to look more attractive. For some of the artists, like Renoir, there was a crisis in artistic confidence too, a sense that the sketchiness of Impressionism masked a failure to come to terms with the importance of drawing and the authority of the art of the past.

Renoir's *The Umbrellas* [53] makes this changing attitude clear. The painting was executed in two campaigns, the first around 1881, the second about

OPPOSITE
53. Pierre-Auguste Renoir, *The Umbrellas*, about 1881–6. 180.3 x 114.9 cm.

RIGHT
54. Detail of 53.

1885–6. The figures on the right, the woman and the two young girls, all fashionably dressed in the style of 1881, are painted with short feathery brushstrokes, with hardly any sense of drawing [54]. Renoir left this area almost untouched when, some five years later, he

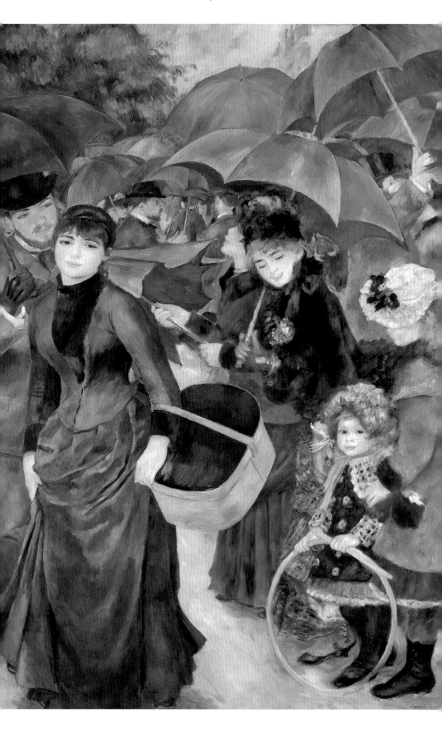

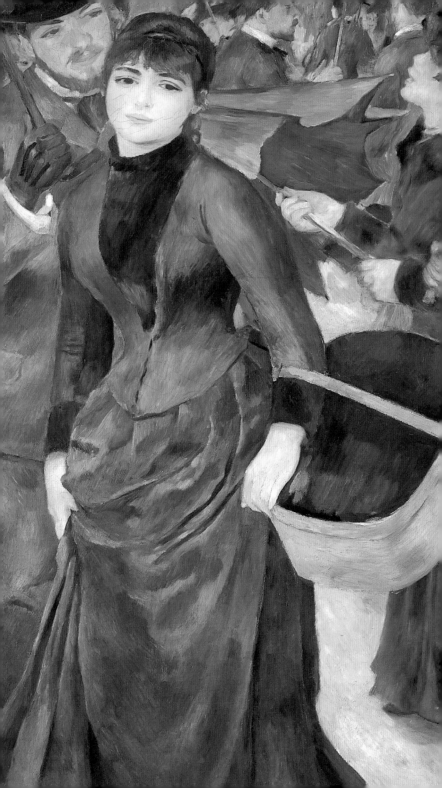

began to rework the figures on the left. The woman in the foreground [55], carrying a bandbox, is painted with a far greater precision – the line separating her from the surrounding figures is crisply indicated, and her face is far more specifically delineated than that of the woman on the right. The manner in which her dress is painted is one of the indications of the increasing influence of Cézanne on the younger artist: Renoir had visited his colleague in Provence early in 1882, and the folds of the cloth are suggestive of one of Cézanne's landscape paintings of the time.

55. Detail of 53.

Renoir unites the many figures in this large painting by the umbrellas which crowd the upper half of the canvas. He suggests the bustle and diversity of the Paris streets, with their endless possibilities for chance encounters (note how the man on the left leans towards the woman, apparently offering her the shelter of his umbrella) and of contact between the classes – the working-class woman on the left, bare-headed, her bandbox suggesting that she is out on an errand; the elaborately dressed child on the right, being taken to the park to play with her hoop. In *The Umbrellas* Renoir tackled the challenge of painting a sizeable multi-figure composition, a challenge posed by history painting, and one which influenced his choice of subjects – this was the last of his large-scale paintings of contemporary urban life.

Renoir had always been interested in representing the human figure. *Nymph by a Stream* [13], for example, made a traditional association between woman and nature, while also showing the importance for Renoir's generation of Courbet's Realism. Renoir's interest and delight in showing the blue veins beneath the model's white skin in this work is at least as great as his interest in the depiction of the stream and its surroundings. Renoir is often seen as the consummate Impressionist landscapist, but landscape painting became for him a dead end, lacking the engagement with the great tradition of art he had so valued in the 1860s, and with which he resumed a dialogue in the 1880s. He travelled to Italy to study paintings from Pompeii in Naples and Raphael's decorations for the Villa Farnesina in Rome. He travelled too to North Africa to immerse himself in the bright light and colour there, in the footsteps of Delacroix, the great colourist, whom he had long admired.

Around 1880, Pissarro began to paint images of the human figure in a quite different way from that employed in his earlier work. Previously, the figures tended to be small accents in a landscape, but as Pissarro reconsidered his position in relation to Impressionism, the figure came to dominate its surroundings. They are usually peasant women, as in *A Wool-Carder* [56], painted in 1880, in which the focus of the painting is entirely on the individual absorbed in her task. Like other paintings by Pissarro of this period, she does not engage with the viewer, and is both close to us and remote, as if we were looking at her through a one-way mirror. In *The Pork Butcher* of 1883 [58], the powerful figure of the young woman is set among the stalls of the market at

58

57. Detail of 58.

58. Camille
Pissarro,
The Pork Butcher,
1883.
65.1 x 54.3 cm.

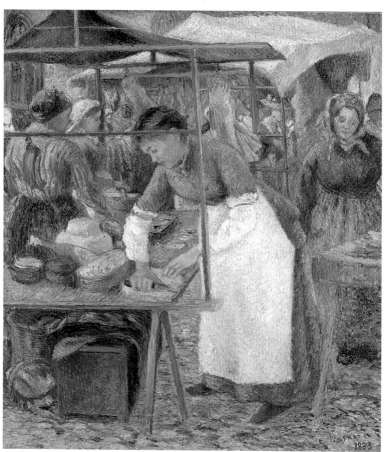

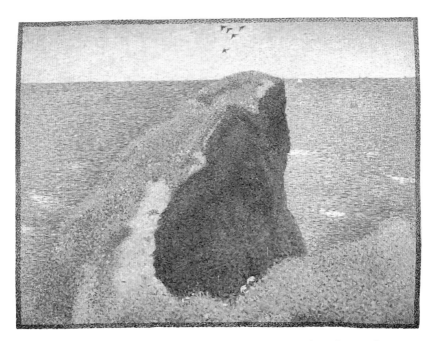

59. Georges-Pierre
Seurat,
*Le Bec du Hoc,
Grandcamp*, 1885.
64.8 x 81.6 cm.

Pontoise, but it was probably painted in the studio,
with the artist's niece, Nini, acting as model [57].
Close examination reveals many changes as Pissarro
struggled to get the proportions and pose as he
wanted them. Pissarro's brushstroke was becoming
smaller and smaller at this time, and he was concerned
not just to contrast individual strokes of comple-
mentary colours, as had been his and the other
Impressionists' practice in the early 1870s, but to cre-
ate complementary colour harmonies in large areas of
the canvas, with these broad harmonies picked up and
echoed in the relationship of individual brushstrokes.
Although this painting is not executed in the technique
of small dots, known as pointillism, which he later
adopted in emulation of Georges Seurat [59], it does
show an increasingly systematic approach to the
application of colour. Brushstrokes no longer vary
according to the surfaces they describe, but are much
more uniform, and the links between colour areas are
carefully constructed, rather than intuitive as, for
example, in Monet's work of the 1870s. It is hardly
surprising that Pissarro, given this methodical
approach, was struck by what he called Seurat's
'scientific' Impressionism, and came to contrast it with
the 'romantic' Impressionism of artists like Monet.

The figure was always the key element in Degas's practice, and its dominance is one of the reasons for his awkward fit into any conventional definition of Impressionism. *Hélène Rouart in her Father's Study* [60], painted about 1886, portrays the young woman placed behind an empty chair. This curious arrangement is usually read as an indication of the force of her absent father in this claustrophobic room, his study, but the empty chair may also suggest the death of her mother, whose family were furniture designers. The space seems too shallow to accommodate the figure, which is squeezed between the chair, a glass display case containing some of her father's

60. Hilaire-Germain-Edgar Degas, *Hélène Rouart in her Father's Study*, about 1886. 161 x 120 cm.

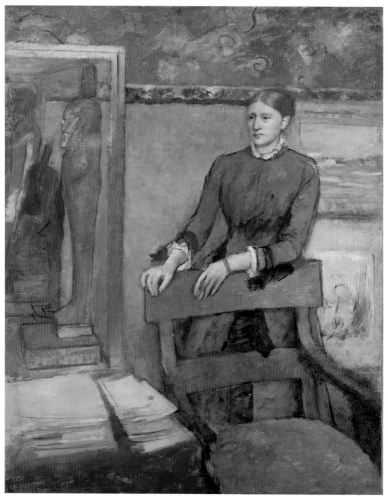

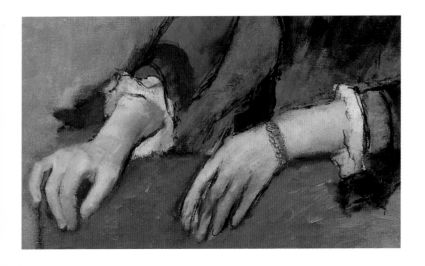

collection of Egyptian statuettes, the painting to her right (a study of the Bay of Naples by Corot), and the drawing by Millet below it. Degas, a brilliant draughtsman, has deliberately described her hands with great clumsiness [61], so that she appears quite inelegant and ill at ease among her father's trophies.

DEGAS, REPETITION, AND THE SERIES

Degas believed: 'It is essential to do the same subject over again, ten times, a hundred times.' This point of view is in striking contrast to one view of Impressionism, that it captures a specific moment at a specific time. For Degas, the importance of repetition is evident in his endless reprise of the theme of women washing and drying themselves. *After the Bath, Woman drying herself* [63] is, like many of these images, structurally complex: it consists of several pieces of paper mounted on cardboard. Working in pastel, his favourite medium in his later years, Degas looks down on the back of the woman. The face, like almost all the faces in these works, is invisible, and Degas is concerned to impress upon us the awkwardness of the figure's movements, one hand holding the edge of the bath tub, the other drying the back of the neck. 'Drawing isn't what you see, it's a question of what you can make other people see', Degas maintained, and here he makes us see a classical subject, the nude, transformed by the less-than-fluid movements of everyday life, the clumsiness adding pathos and interest to a humdrum moment.

62. Detail of 63.

63. Hilaire-Germain-Edgar Degas, *After the Bath, Woman drying herself*, probably 1888–92. 103.8 x 98.4 cm.

62

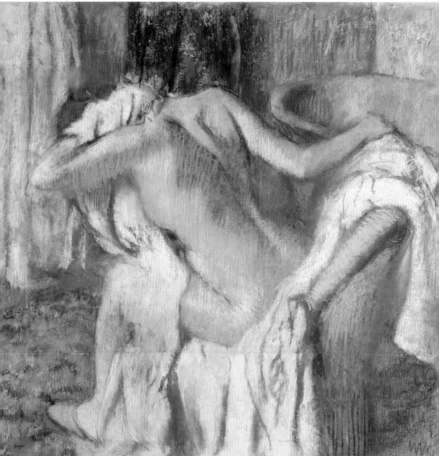

63

64. Hilaire-
Germain-Edgar
Degas,
*Combing the Hair
(La Coiffure)*,
about 1896.
114.3 x 146.1 cm.

In *Combing the Hair* [64], Degas returned to a
theme he had explored many times (for instance in
his *Beach Scene* [36] exhibited in 1877). In this work
of around 1896 the relationship between the two fig-
ures is less clear. The seated woman appears to be
pregnant and expresses discomfort as the maid
brushes the mane of hair. The use of reds is very bold:
the red-haired figure in her red dress and the red-
haired attendant in a pink blouse are set against a red
ground with a red swath of curtain in the corner. The

defining lines are broad, and the precise detail of the
earlier painting is abandoned in favour of overall
effect. For Degas, as for Pissarro, Sisley and Monet,
repetition seemed the only way to investigate the
apparently endless nuances of a single subject. Unlike
his colleagues, however, Degas was not interested in
changes in light and weather conditions which led to
the different appearances of surfaces, but in the com-
plexities of even the simplest pose and its potential for
exploration in a variety of media and differing moods.

Pissarro produced several series of paintings in the 1890s, in particular views of Paris and other northern French cities. At a time when his colleagues had moved away from depictions of the city which had so fascinated them in the 1860s and 1870s, Pissarro returned to Paris, attempting to capture its modernity, but also to contrast urban life with his continuing exploration of rural themes. Like both Monet and Degas, Pissarro experienced problems with his sight, and found working out of doors increasingly difficult as he grew older. His Paris series are all painted from the windows of hotels, looking down at the scene below, emphasising the artist's remoteness from the teeming streets and pavements. In *The Boulevard Montmartre at Night* [65], the street is slicked with rain, and the streetlights create brilliant reflections. Pissarro painted this, the only night scene of the series, from the window of the Grand Hôtel de Russie early in 1897. Lines of carriages wait at the sides of the road, and the pavement is thronged with passers-by, painted in an extremely sketchy manner. This work was never exhibited by Pissarro, and was clearly experimental, an attempt to capture the glow of streetlighting and the illumination of shop windows which made Paris at night a dazzling spectacle.

65. Camille Pissarro, *The Boulevard Montmartre at Night*, 1897. 53.3 x 64.8 cm.

66. Detail of 65.

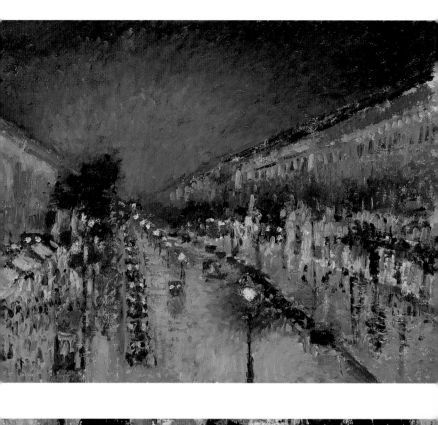

In the years after the Impressionist group shows, repetition became the dominating theme for Monet. Although Degas and Monet seem in some ways to be at opposite poles – Degas the observer of city life and of the human figure, Monet the landscapist, chronicling the outdoors and the effects of light and reflection – in this respect they shared much common ground. When Monet painted eleven views of the Gare St-Lazare in 1877, he was embarking on an idea that he explored far more systematically in the late 1880s and the 1890s, the idea of a series. Inherent in many early Impressionist paintings, like Monet's own *The Beach at Trouville* [20], is the suggestion that if this is one particular effect of light and weather, another hour, even another minute, may offer a very different view of the same scene. In *Poplars on the Epte* of 1891 [67], Monet began to resolve some of the implications of this thinking. This is one of the most lightly worked and freely painted of his series of twenty-three views of a row of poplars on the river Epte, close to Monet's home at Giverny in Normandy. In order to preserve his subject from the depredations of the wood-cutter, Monet was forced to enter into an agreement with the local timber merchant until he had completed the series. He probably painted the screen of trees from a boat, intent on creating a harmony between the curve of the leafy tops of the poplars and the verticals of their slender trunks. Even in this swiftly worked painting, at least two sessions were involved: the blue of the sky was intensified and three tree trunks were moved about a centimetre to the right after the first layer of paint had dried. This second session may or may not have taken place out of doors: by this stage of Monet's career, it is extremely difficult to differentiate between work done outside, in front of the object, and work done in the studio.

Monet's repetitions are most vividly seen in his renderings of the lily pond and Japanese footbridge at Giverny. Monet had bought land in 1893 to construct a water garden 'for the pleasure of the eye and also for motifs to paint', diverting the river Epte in the process. These motifs proved sufficiently compelling to engage him until his death in 1926. *The Water-Lily Pond* [68] of 1899 is one of eighteen views by Monet of the pond and footbridge together, twelve of which were exhibited together in Paris in 1900. The bridge bisects

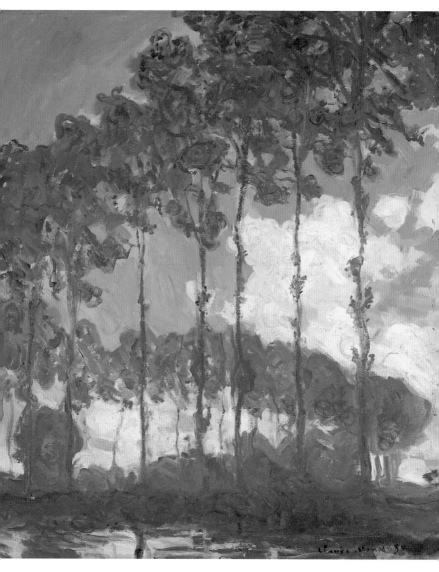

the canvas, emphasising the two-dimensionality of the picture surface, while the pond itself gives the illusion of three-dimensionality. In this respect, the painting is very similar to his views of La Grenouillère, painted thirty years earlier. But here there is much to suggest that Monet worked and reworked the densely layered surface of the lily pond over a period of time, waiting for successive paint layers to dry before applying further touches. Monet said of the pond: 'The effect

67. Claude-Oscar Monet, *Poplars on the Epte*, 1891. 92.4 x 73.7 cm.

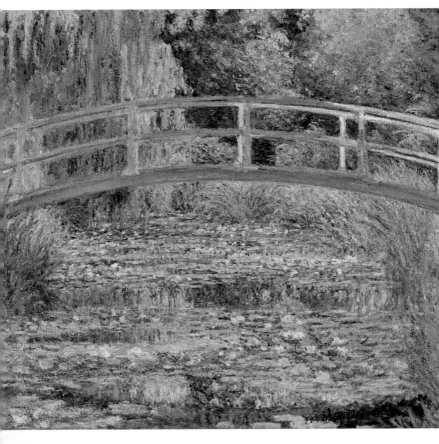

varies constantly, not only from one season to the next, but from one minute to the next, since the water flowers are far from being the whole scene; really, they are just the accompaniment. The essence of the motif is the mirror of water whose appearance alters at every moment.' It was this sensitivity to every change in light and atmosphere that led Monet to paint serially, moving from one unfinished canvas to another to record particular effects.

68. Claude-Oscar Monet, *The Water-Lily Pond*, 1899. 88.3 x 93.1 cm.

69. Detail of 68.

70. Monet on the bridge at Giverny in his eighty-sixth year.

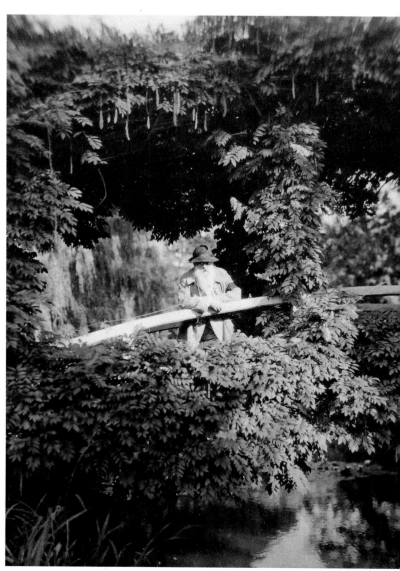

71. Claude-Oscar
Monet,
Irises,
about 1914–17.
200.7 x 149.9 cm.

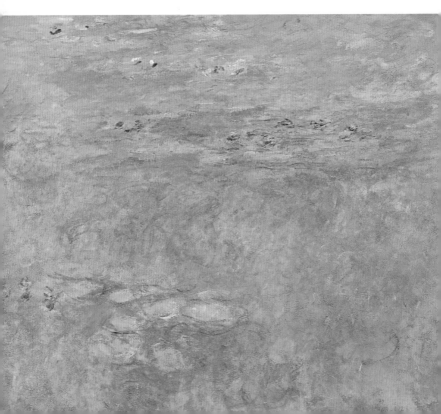

The late paintings by Monet are often very large in size, and *Irises* [71] of around 1914–17 is no exception. Over two metres high, the same height as the largest water-lily paintings, it shows a group of flowers growing along the banks of the lily pond. By this date Monet thought of his paintings as 'decorations', intended to serve almost as murals, far removed in both size and intention from the small easel paintings of the Impressionist years. *Irises* is broadly painted, with very little definition of stems and blooms, rather an overall harmony of blues, greens and yellows. *Water-Lilies* [72] approaches a familiar subject from a different angle, looking down at the surface of the pond. The horizon has disappeared, and with it, any sense of the extent of the space. We share Monet's view of a floating world without boundaries.

72. Claude-Oscar Monet, *Water-Lilies*, after 1916. 200.7 x 426.7 cm.

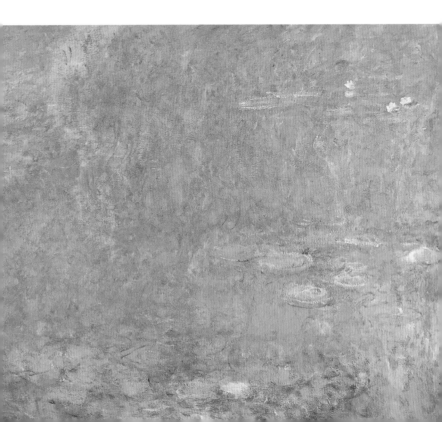

IMPRESSIONISM'S
HISTORY

COLLECTING IMPRESSIONISM

Many artists associated with Impressionism went on producing work well into the twentieth century – in the case of Monet, until 1926, after the First World War, after Cubism, Dada and the advent of Surrealism. For most, Impressionism was one moment in their careers, a crucial moment when they were defining their artistic practice and their approach to exhibiting their work. From that moment, in the early and mid-1870s, they went on to explore other avenues, although they continued to share many concerns, even in the case of very different painters such as Degas and Monet. Impressionism was vital in how they were initially perceived as a group and how their work came to be discussed, and it is still used as a blanket term long after it has any specific meaning for the artists in question – long after the group exhibitions had ceased, for instance.

The key dealer in the history of Impressionism, Paul Durand-Ruel, saw this group identity as useful in promoting the artists he showed, and it was through exhibitions in the United States and the influx of American buyers into France that Impressionist art entered museums and private collections in the United States. Yet when the painter Gustave Caillebotte died in 1894, there was some reluctance on the part of the French State to accept his magnificent collection of paintings by Impressionist artists, now the nucleus of the Musée d'Orsay in Paris.

THE NATIONAL GALLERY AND IMPRESSIONISM

In England too, the acceptance of Impressionism was gradual. When the critic Frank Rutter launched the French Impressionist Fund in 1905 to ensure that the nation should acquire its first painting by Monet, *Lavacourt under Snow* [73] (or *Snow Effect at Vétheuil*, as it was then known), he was told that the Trustees of the National Gallery would not accept a Monet, even as a gift. The reason given was uncertainty as to whether works by living artists could enter the Gallery – in fact a work by the still-living Henri-Joseph Harpignies was accepted in 1908. Instead, Monet's painting was bought by the prominent art dealer

Sir Hugh Lane, and bequeathed by him to the Gallery in 1917, along with several other remarkable paintings from his collection, among them Renoir's *The Umbrellas*. Monet was, of course, still alive, and opposition to the acquisition, or even the loan of Impressionist paintings, was strong. In 1914 Lord Redesdale, a Trustee of the Gallery, declared: 'I should as soon expect to hear a Mormon service being conducted in St Paul's Cathedral as to see an exhibition of the works of the modern French Art-rebels in the sacred precincts of Trafalgar Square.' By the 1920s attitudes were changing, and in 1923 Samuel Courtauld's gift to the Tate Gallery (then an adjunct of the National Gallery) of £50,000 for the purpose of acquiring French art made possible the acquisition of several important paintings, among them Monet's *The Beach at Trouville*, Pissarro's *The Boulevard Montmartre at Night*, and Degas's *Miss La La at the Cirque Fernando*. Other works by Degas, dispersed at the wartime sale of his studio, were acquired by the Courtauld Fund, including, in 1924, *Young Spartans Exercising*. Since then, the National Gallery's Impressionist collection has expanded steadily and continues to do so.

73. Claude-Oscar Monet, *Lavacourt under Snow*, about 1878–81. 59.7 x 80.6 cm.

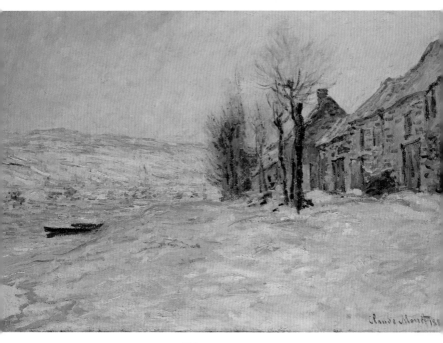

Interest in the Impressionist painters keeps on growing, with exhibitions of their work attracting huge crowds to museums and galleries throughout the world. The prices some of their paintings have fetched on sale at auction houses have been a matter of much public wonderment, even bafflement. Part of the continuing appeal of a work by Monet or Renoir must be that it shows us what now appears to be an idyllic world, a simpler world in the past, to which we can look with nostalgia. This is a world of sunlit days on the river, of excursions on steam trains, of elaborate rituals of dressing, and of pleasure. Paintings of such scenes have an immediate and direct appeal: we do not need to be versed in the complexities of biblical stories or classical mythologies to understand an Impressionist painting. The paintings are very direct: it is possible to appreciate the process of their production, rather than this being masked by smoothness of brushstroke and the application of coats of varnish. The colours of Impressionist paintings, too, seem to convey a sense of pleasure and enjoyment in their brilliance and their frequent use of primary colours. And Impressionism today is also famous for being famous: so huge is the reputation of Claude Monet that the mere inclusion of his name in an exhibition title seems to guarantee large audiences. Impressionism now is far removed from the contemporary art scene: it has lost its avant-garde status, and become the most familiar of styles. Yet this familiarity has done nothing to diminish the pleasure such paintings can provide, whether as original works in the National Gallery and elsewhere, or as prints, posters or postcards at home.

OPPOSITE
74. Detail of 28, *Boating on the Seine*,
about 1879–80, by Pierre-Auguste Renoir.

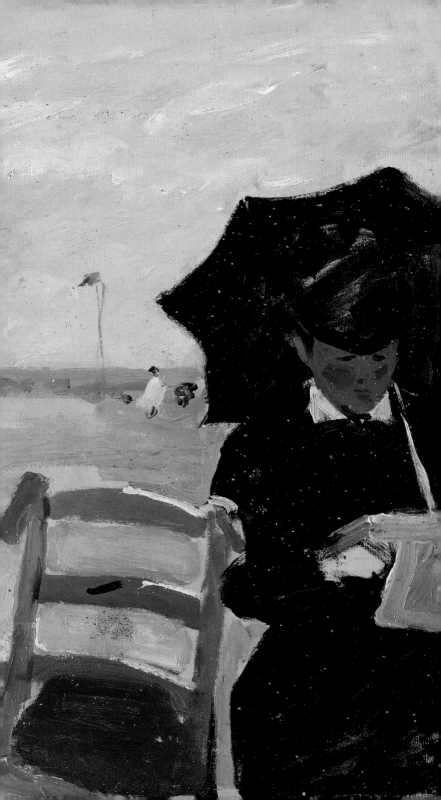

FURTHER READING

The literature on Impressionism and on individual Impressionist painters is vast: this is a small selection.

K. Adler, *Unknown Impressionists*,
Oxford, 1988.

K. Adler and J. Leighton, *London's Monets*,
London, 1997.

B. Denvir (editor), *The Impressionists at First Hand*,
London, 1976.

D. Bomford et al., *Art in the Making: Impressionism*,
London, 1990.

F. Frascina et al., *Modernity and Modernism:
French Painting in the Nineteenth Century*,
London, 1993.

T. Garb, *Women Impressionists*,
Oxford, 1986.

R.L. Herbert, *Impressionism: Art, Leisure and Parisian
Society*,
London, 1988; repr. 1991.

M. Howard, *Impressionism*,
London, 1997.

P. Smith, *Impressionism: Beneath the Surface*,
London, 1995

H.C. White and C.A.White, *Canvases and Careers:
Institutional Change in the French Painting World*,
New York, 1965; repr. 1993.

75. Detail of 20,
The Beach at Trouville, 1870,
by Claude-Oscar Monet.

PICTURE CREDITS